For my dad who taught me how to draw, and

my mum who taught me how to knit ♡xx

Copyright © 2016 by Helen Sharp

All rights reserved. No part of this book may be used or reproduced in any form or by any means, electronic or mechanical, including photocopying, recording or by any other manner without the prior written consent of the author.

ISBN-13:978-1536977141
ISBN-10:1536977144

Created by Helen Sharp

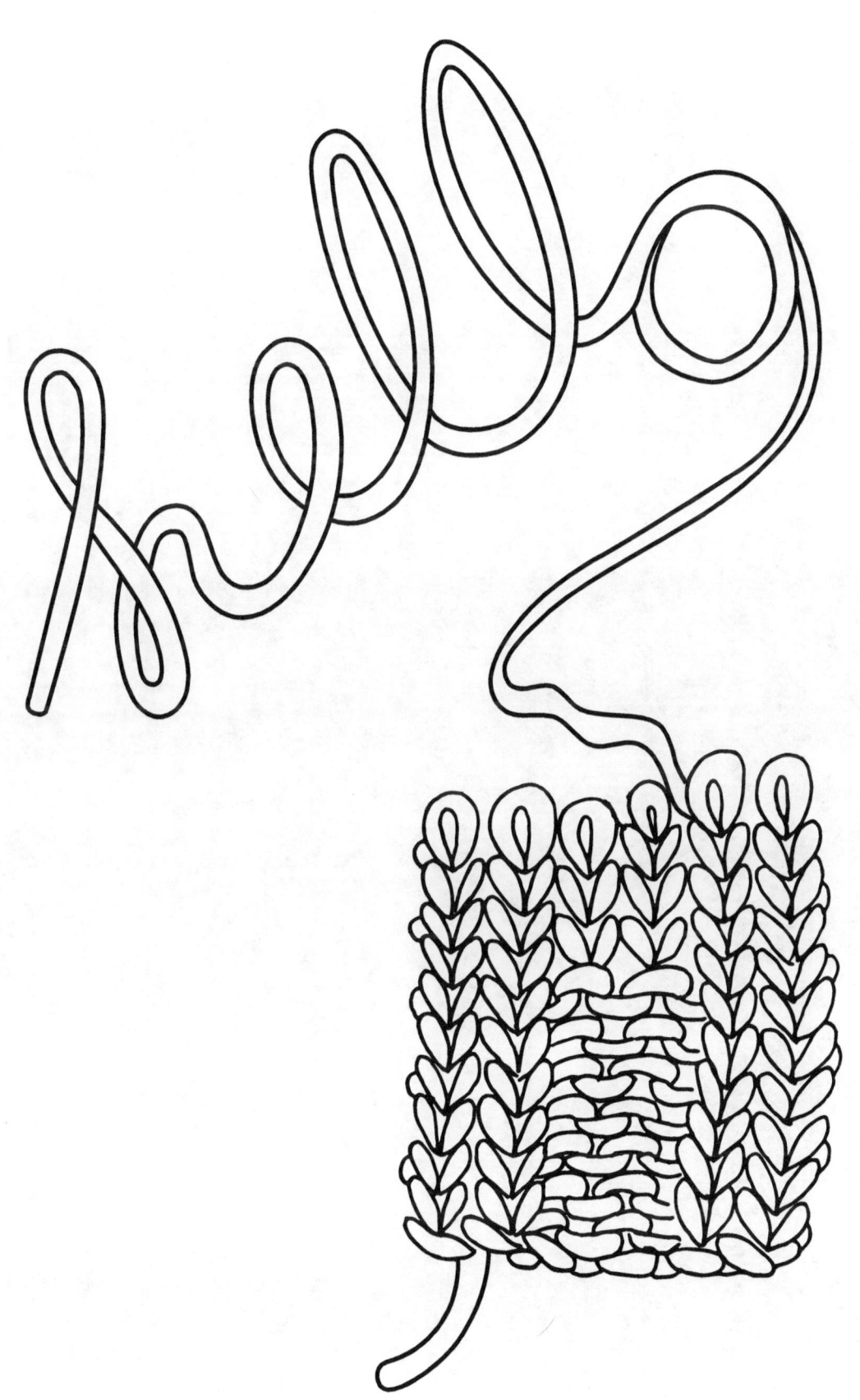

Welcome to The Knitting Coloring Book. I hope you enjoy using it as much as I enjoyed making it.

I have been in love with yarn, knitting and sweaters for over four decades and have worked as a designer and teacher for almost that long.

I have found that my fascination with knitted fabric has changed over the years. From creating original and complex knitted fabrics and garment designs, I have lately become more and more fascinated with the simplest of structures and the path that the yarn takes to form each loop. This led me to make intricate diagrams of basic knitted fabrics like stockinette, lace and cables, painstakingly following the yarn in and out. I became engrossed in coloring in the diagrams, showing the twist of the yarn threads and the shading as it moved behind another yarn. Knitting is a three-dimensional medium and adding shading and shadows lifted the images up from the page.

This book starts with the yarn, just as every knitted project starts, and continues with fabric structures, sweaters and finally complete outfits. I have included some blank graphs so that you can create your own color patterns before transposing them to the blank swatches. There is also a page of mini stitch images for practicing your coloring styles and different coloring mediums.

Inspired by Japanese craft books, I have kept the pages simple and clean with plenty of white space so that the knitting is showcased. This will make it easier to cut out and frame your work if you want to.

Please consider reviewing my book on Amazon. You can find me on Instagram @theknittingschool and at www.theknittingschool.com
Happy knitting and happy coloring!

Helen Sharp

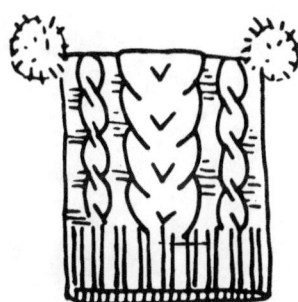

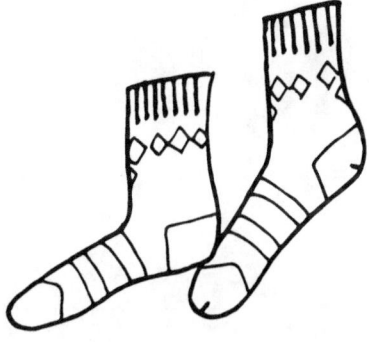

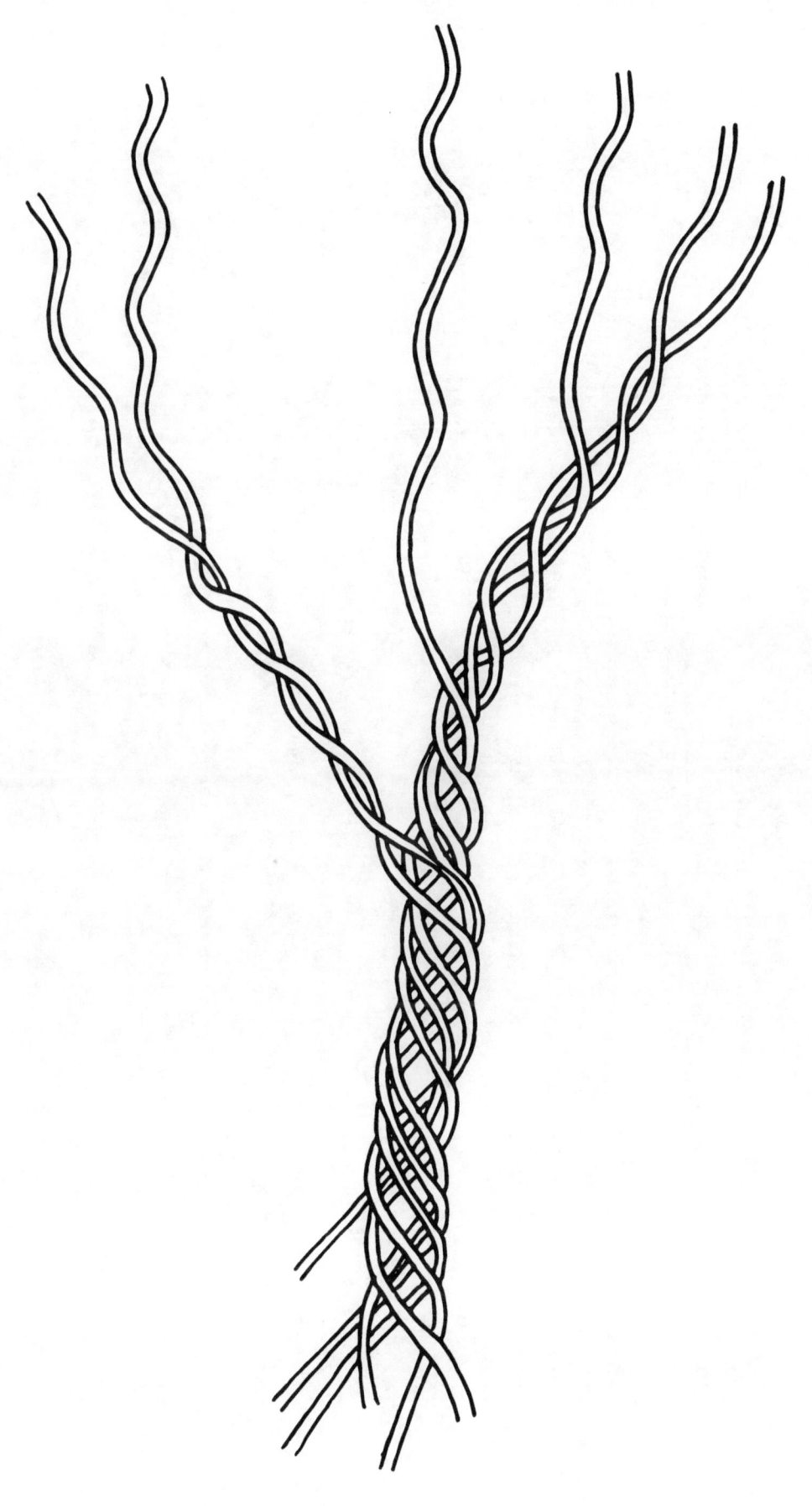

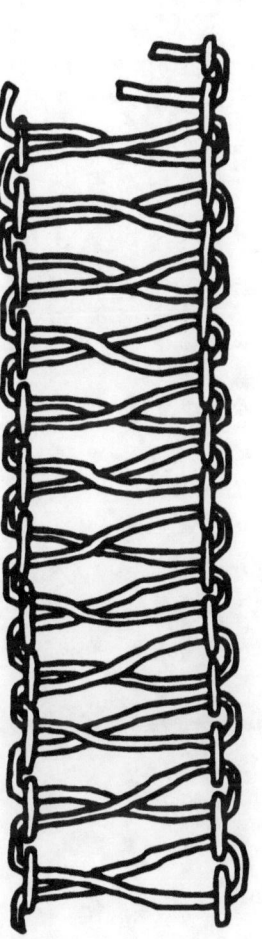

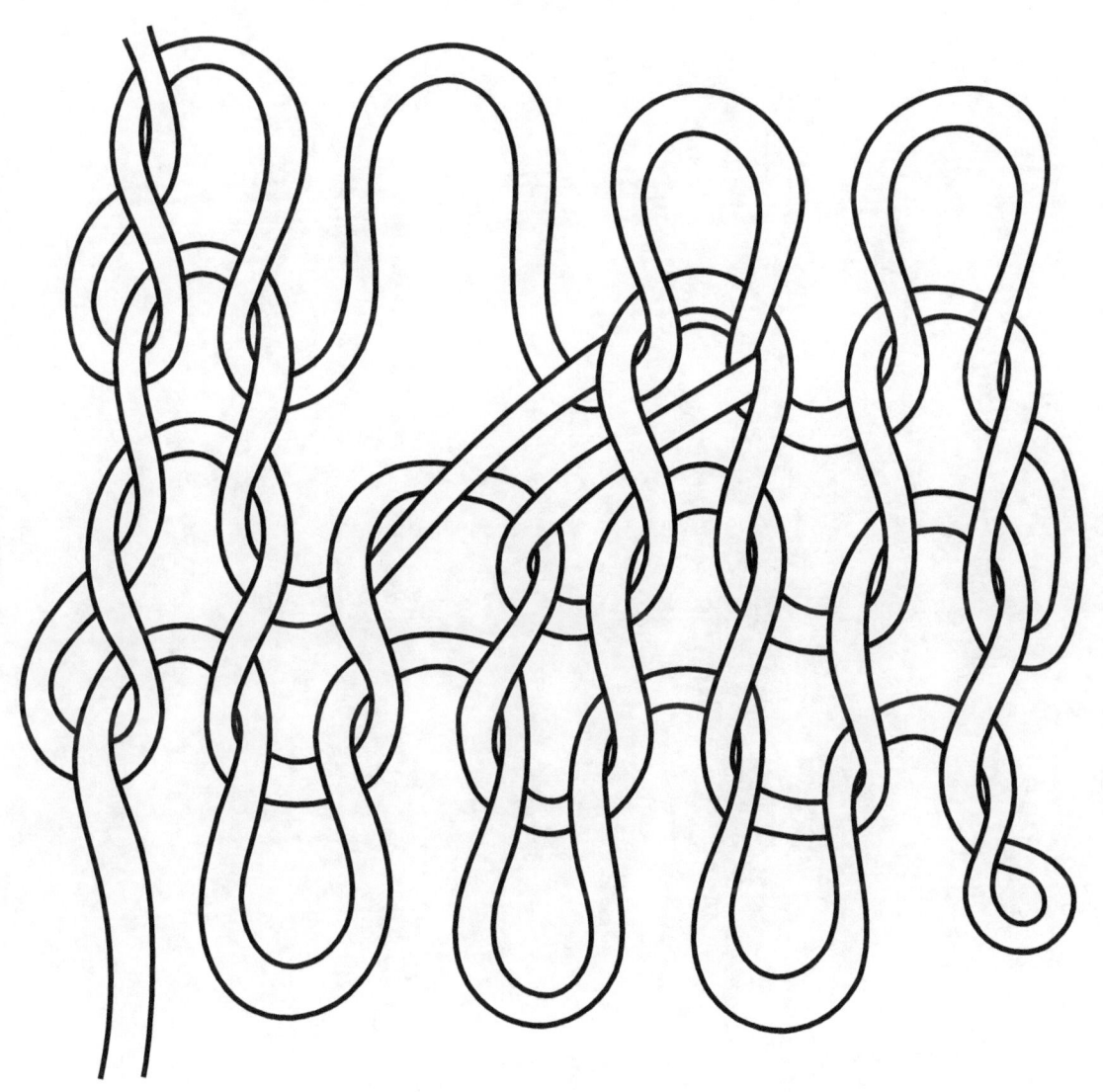

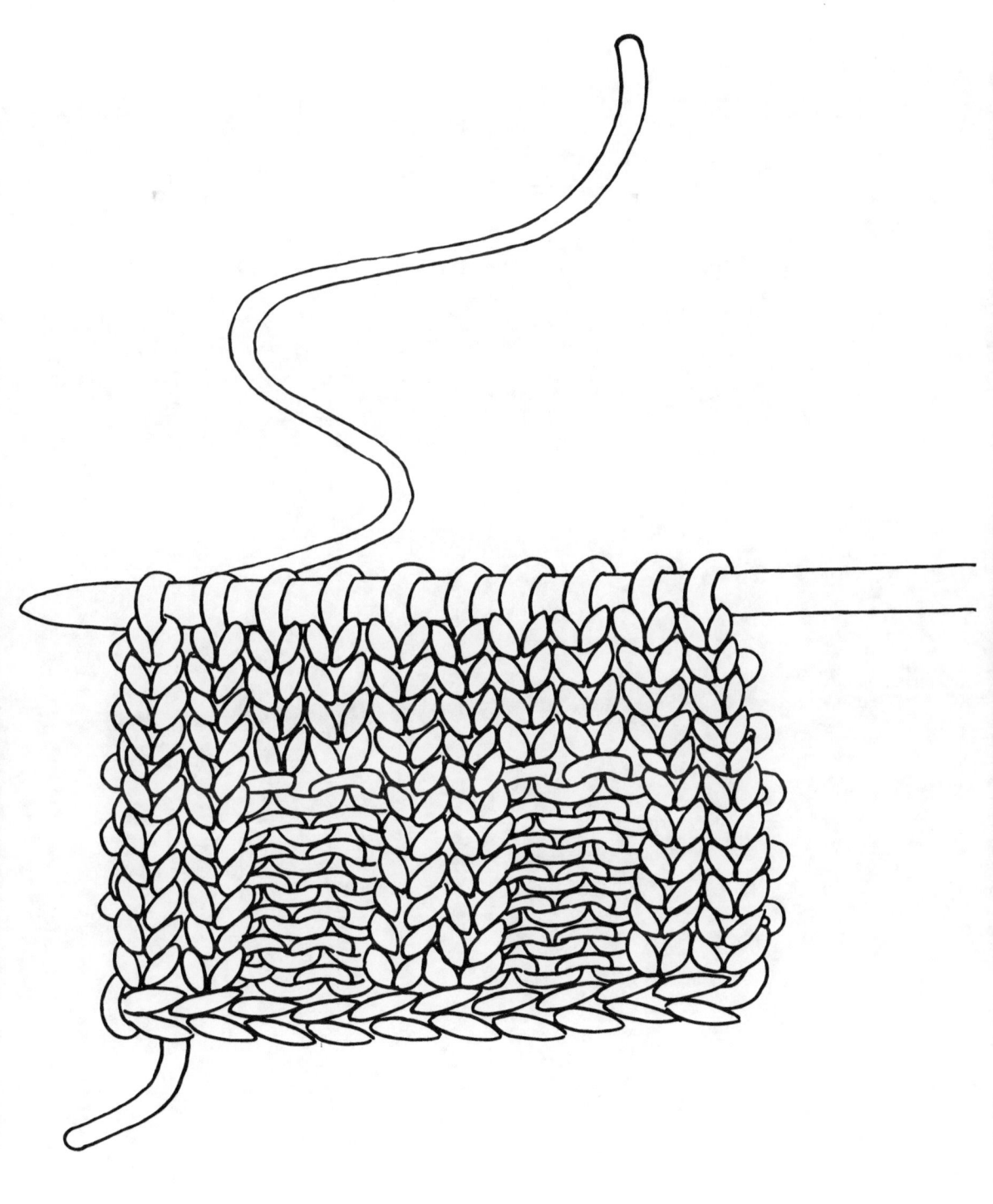

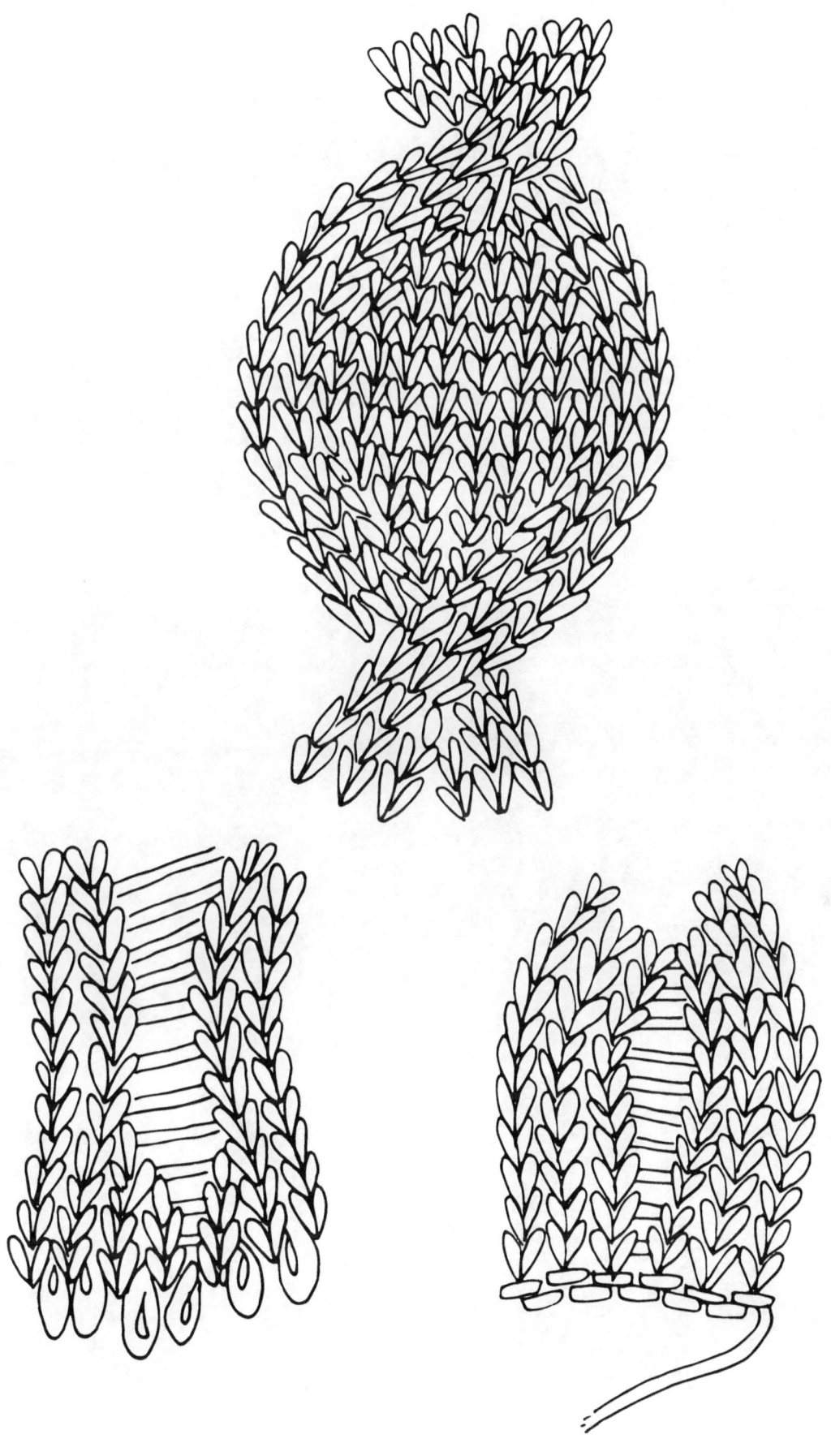

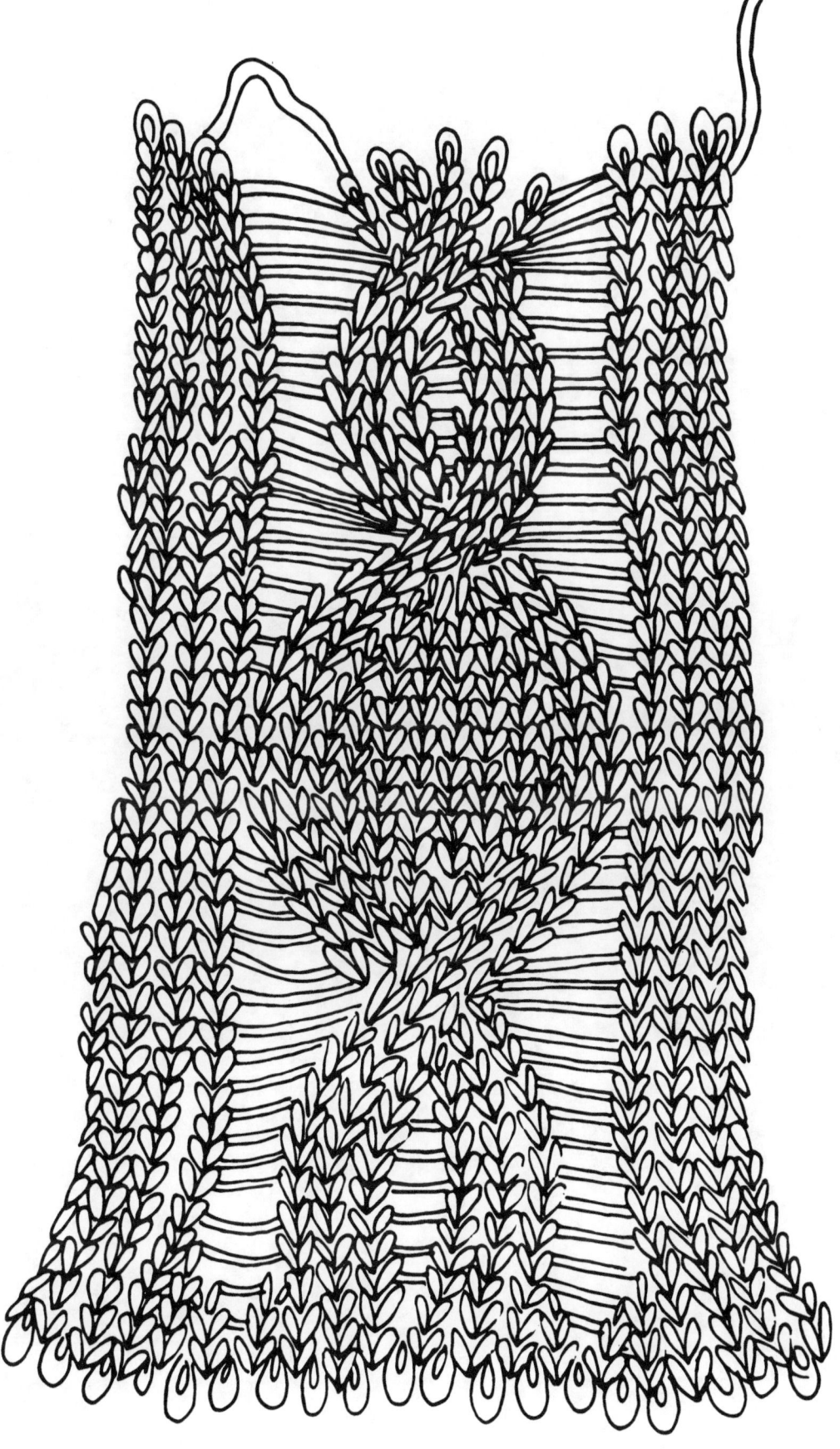

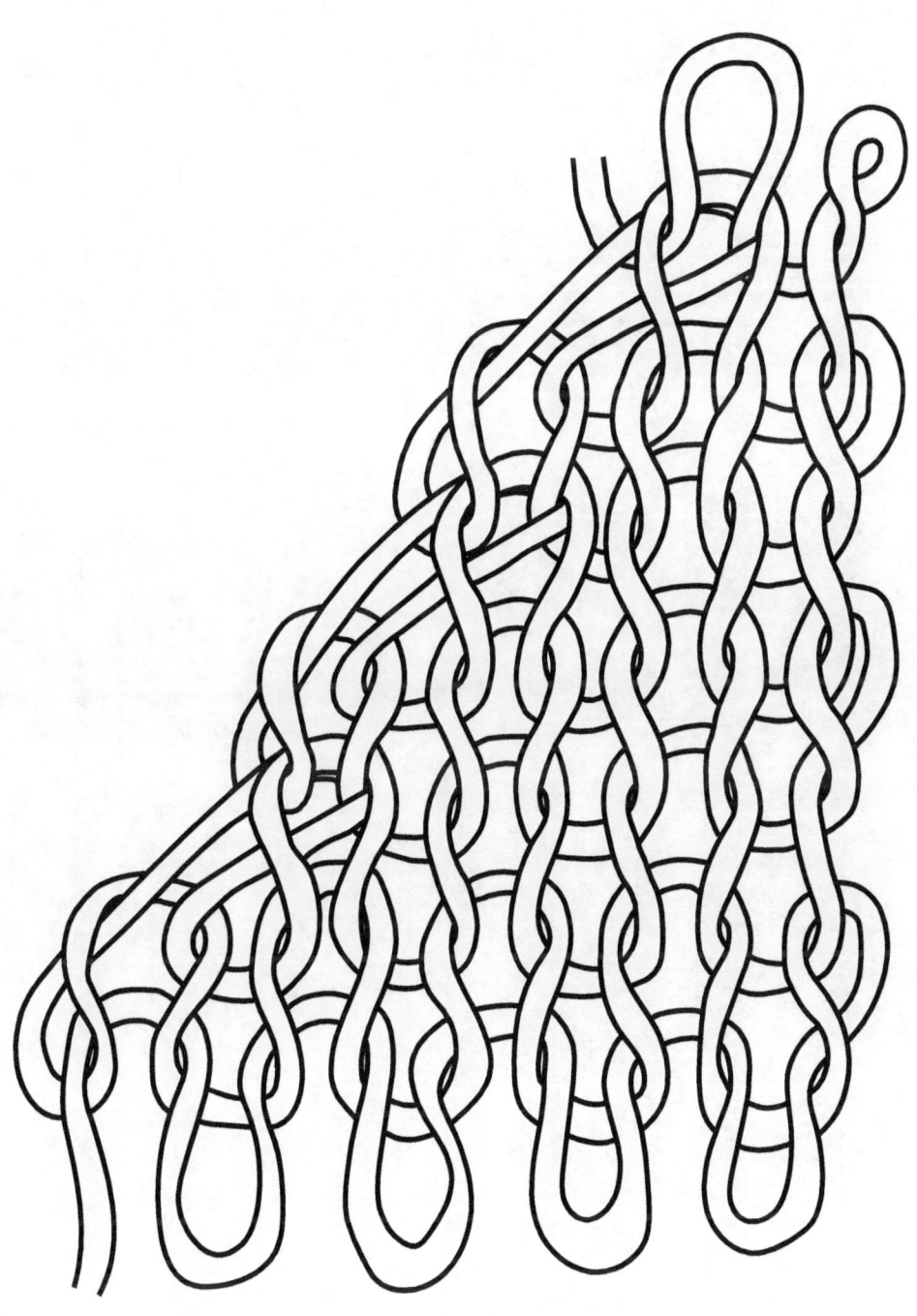

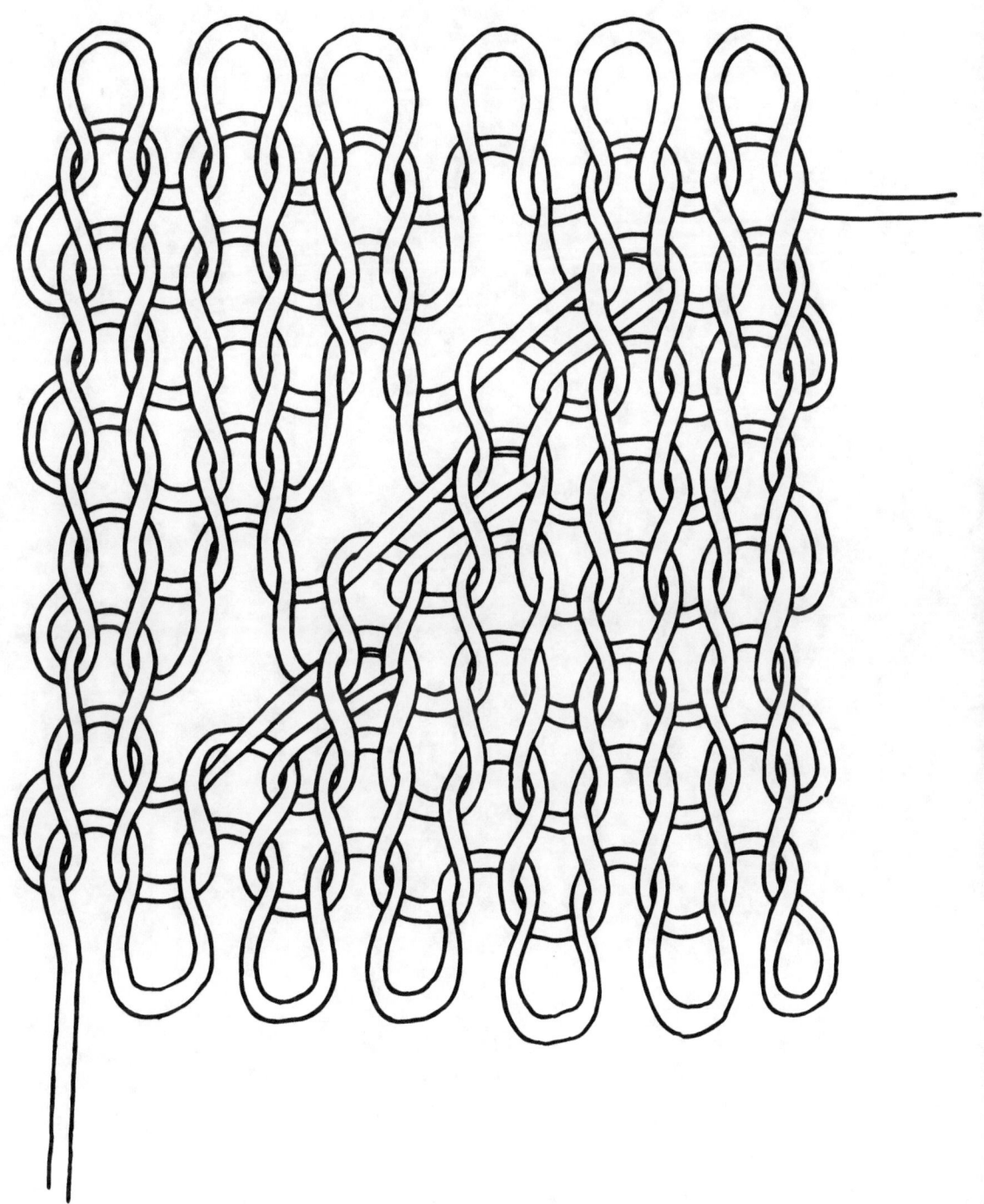

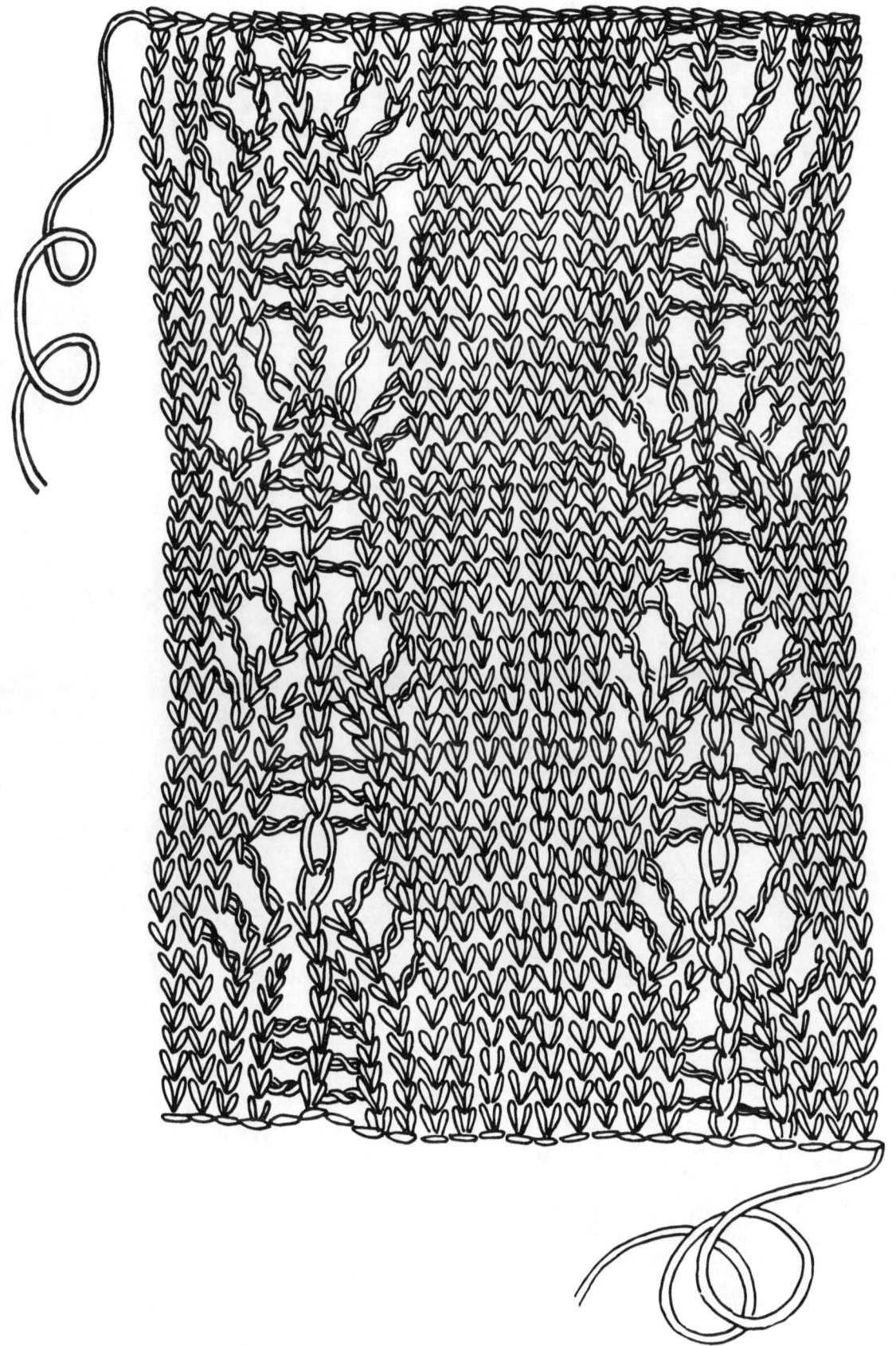

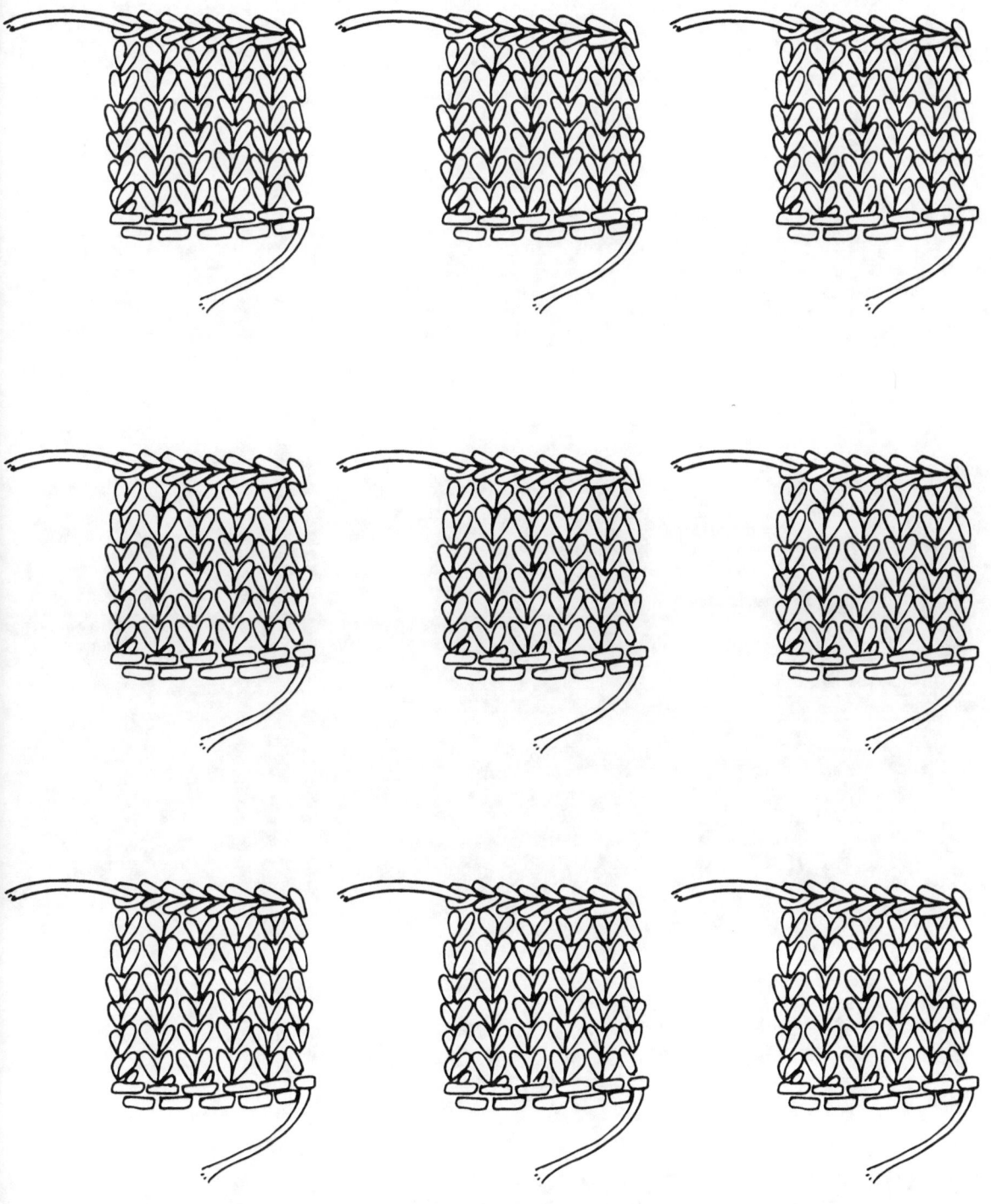

These graphs correspond to the three swatches following. Use the graphs to create your own patterns before transposing them onto the swatches. See back cover for an example. There are extra so you can experiment. The nine small swatch sketches on the previous page can be used for playing around with different coloring techniques or trying different mediums.

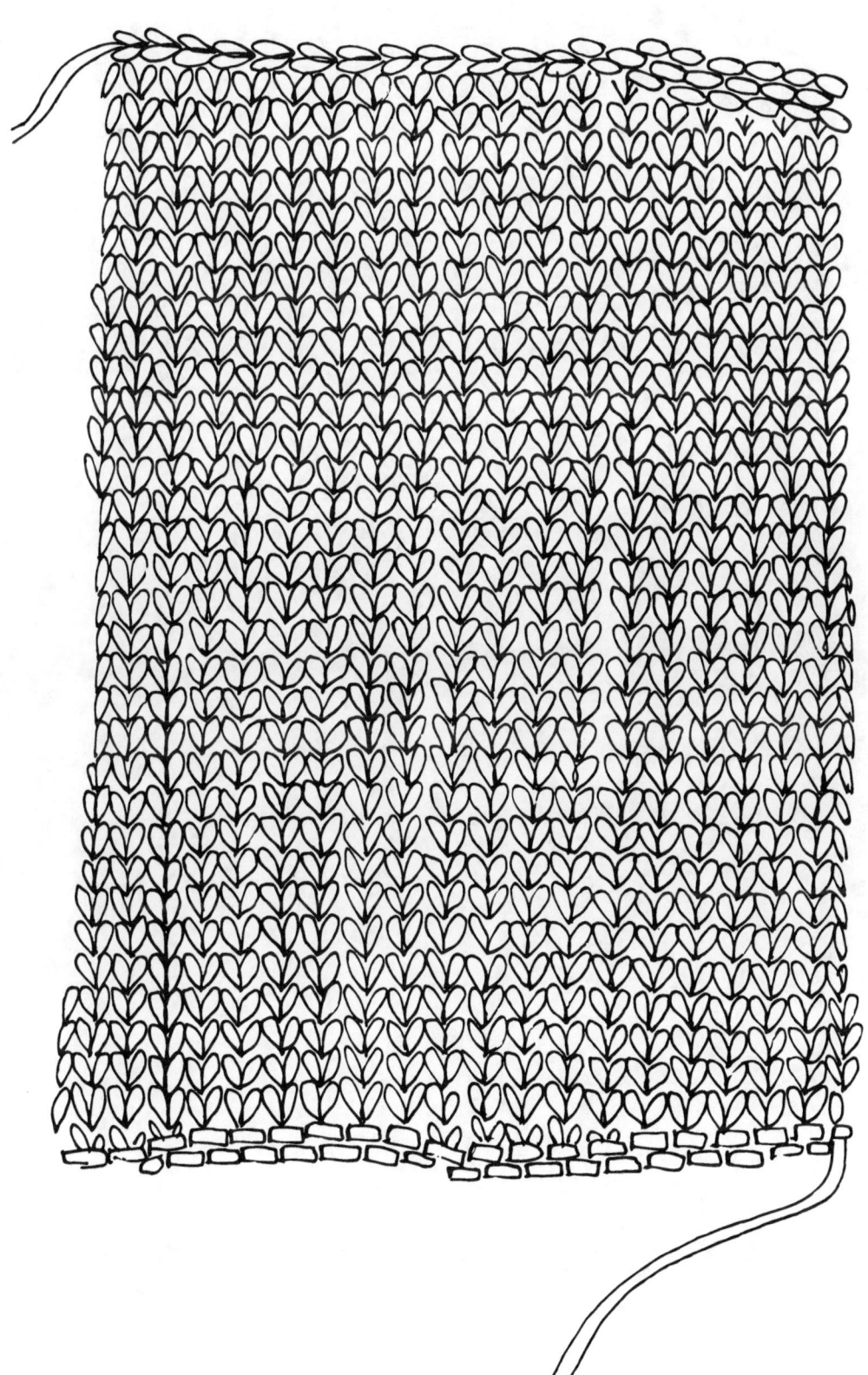

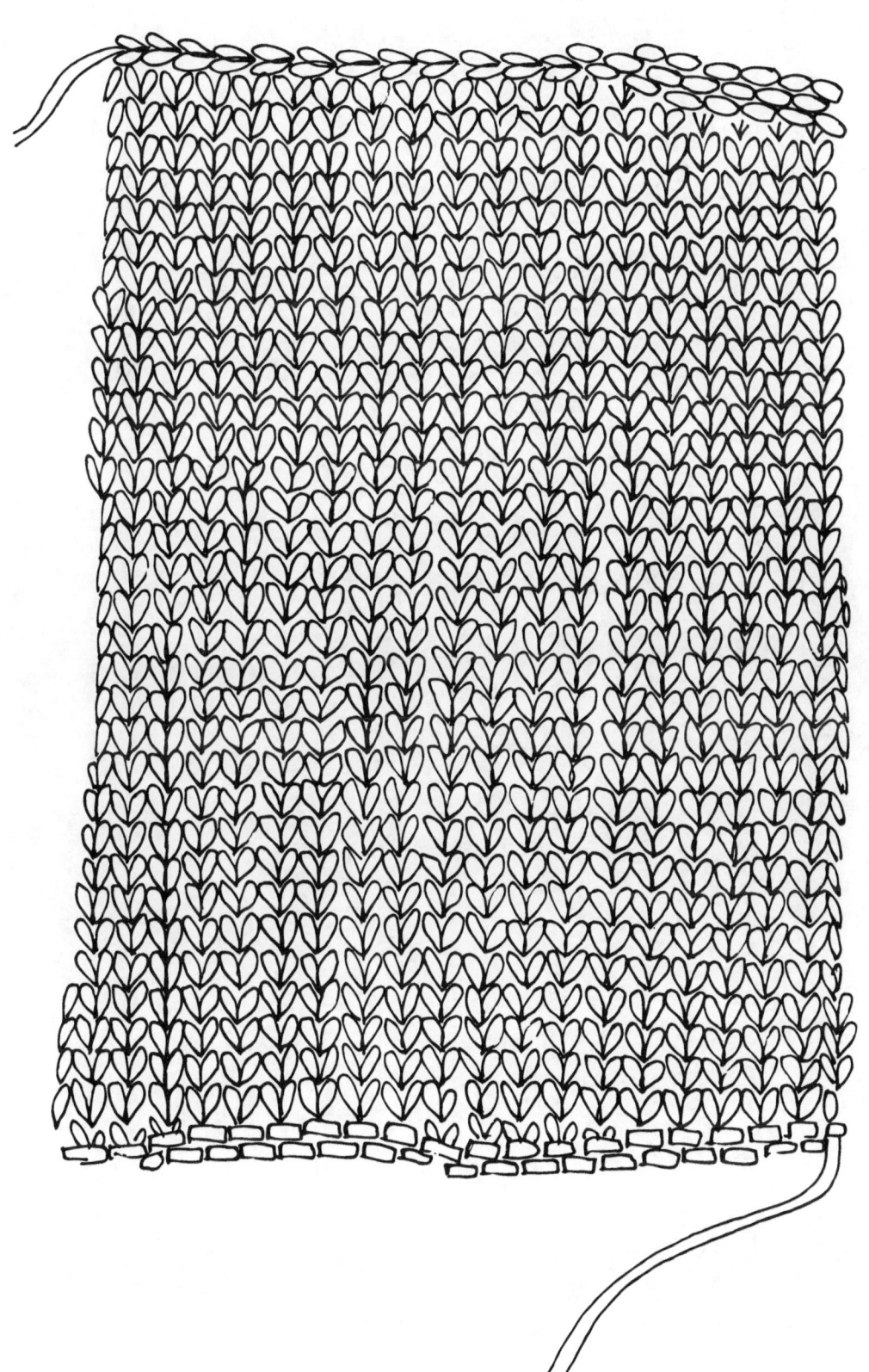

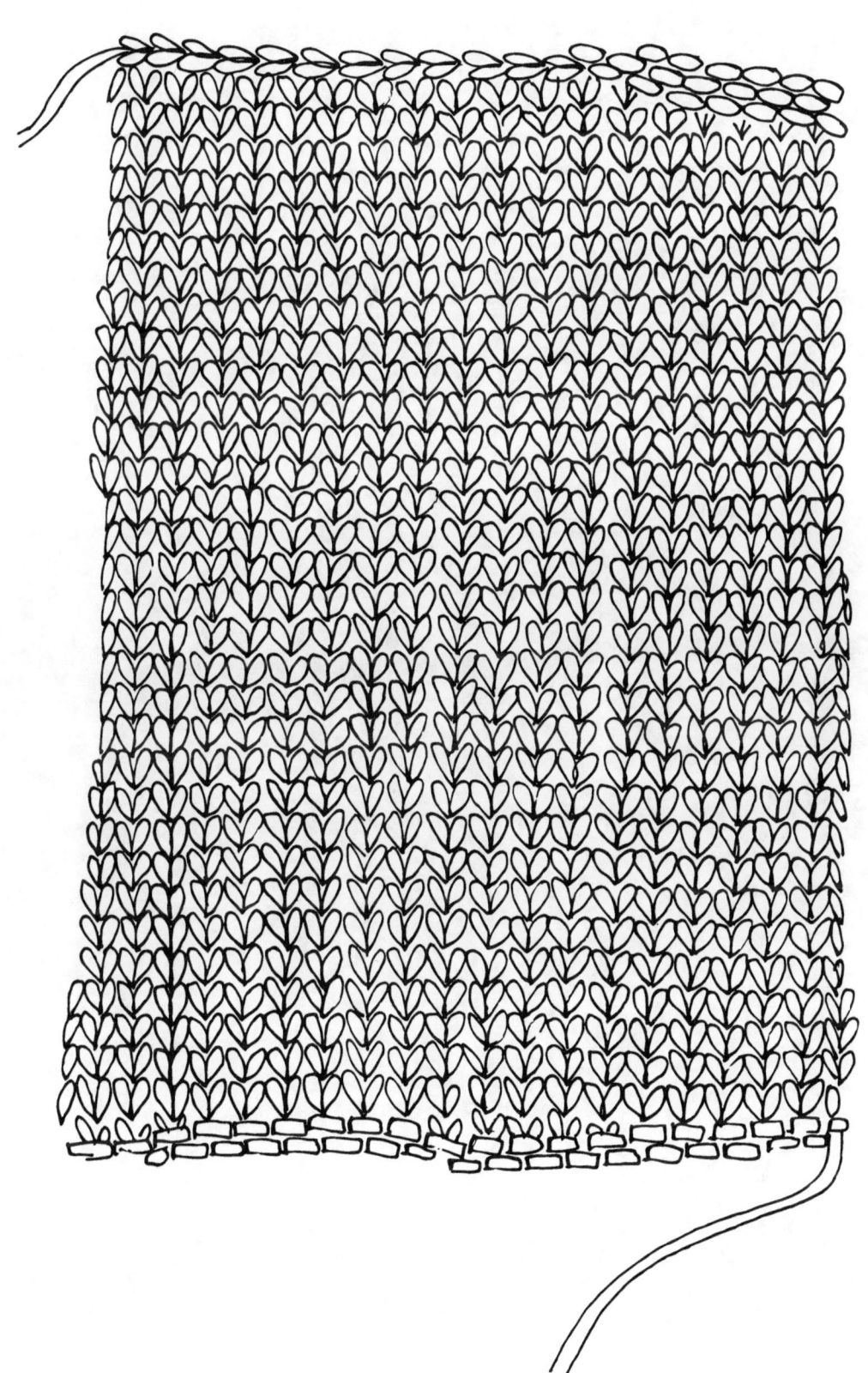

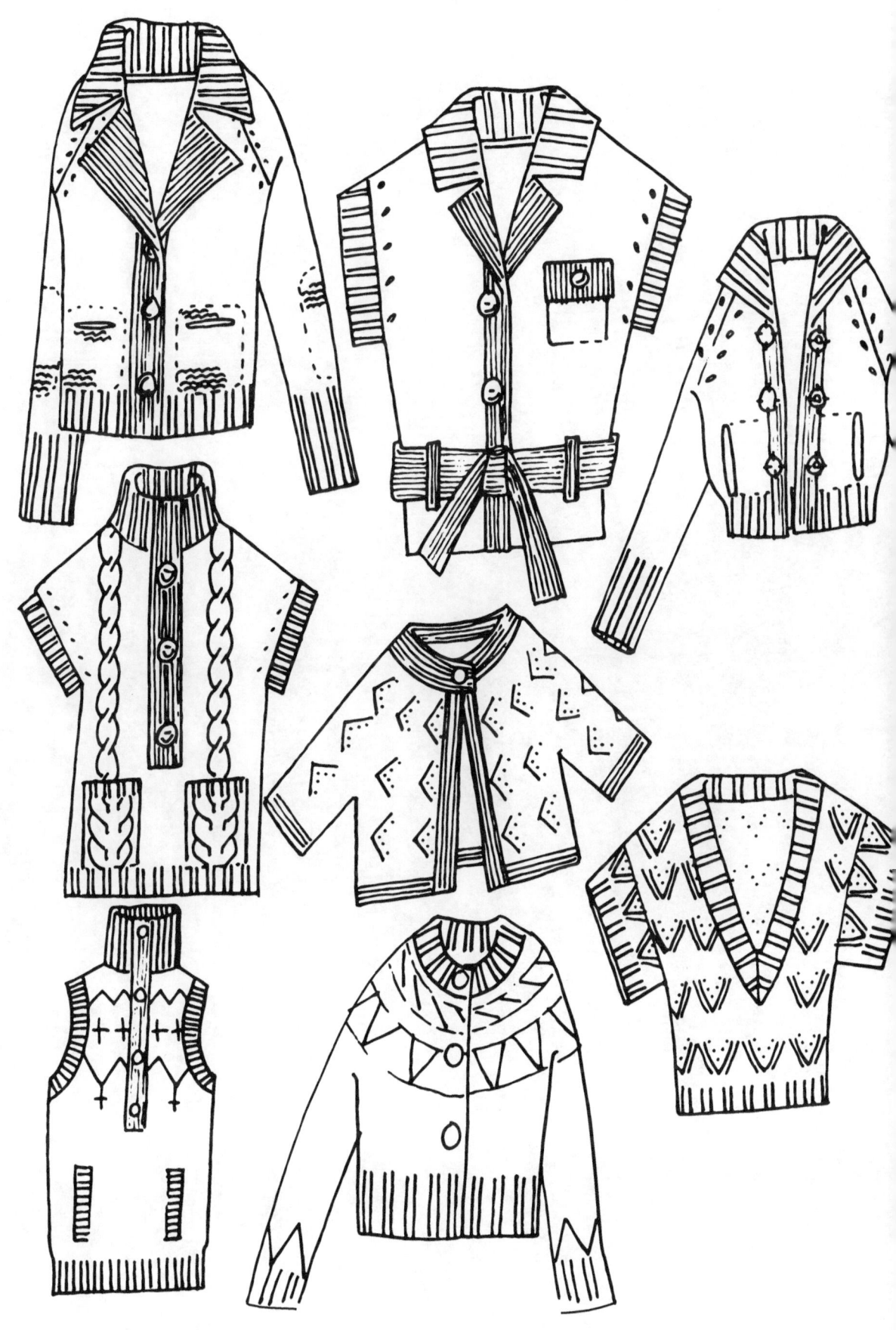

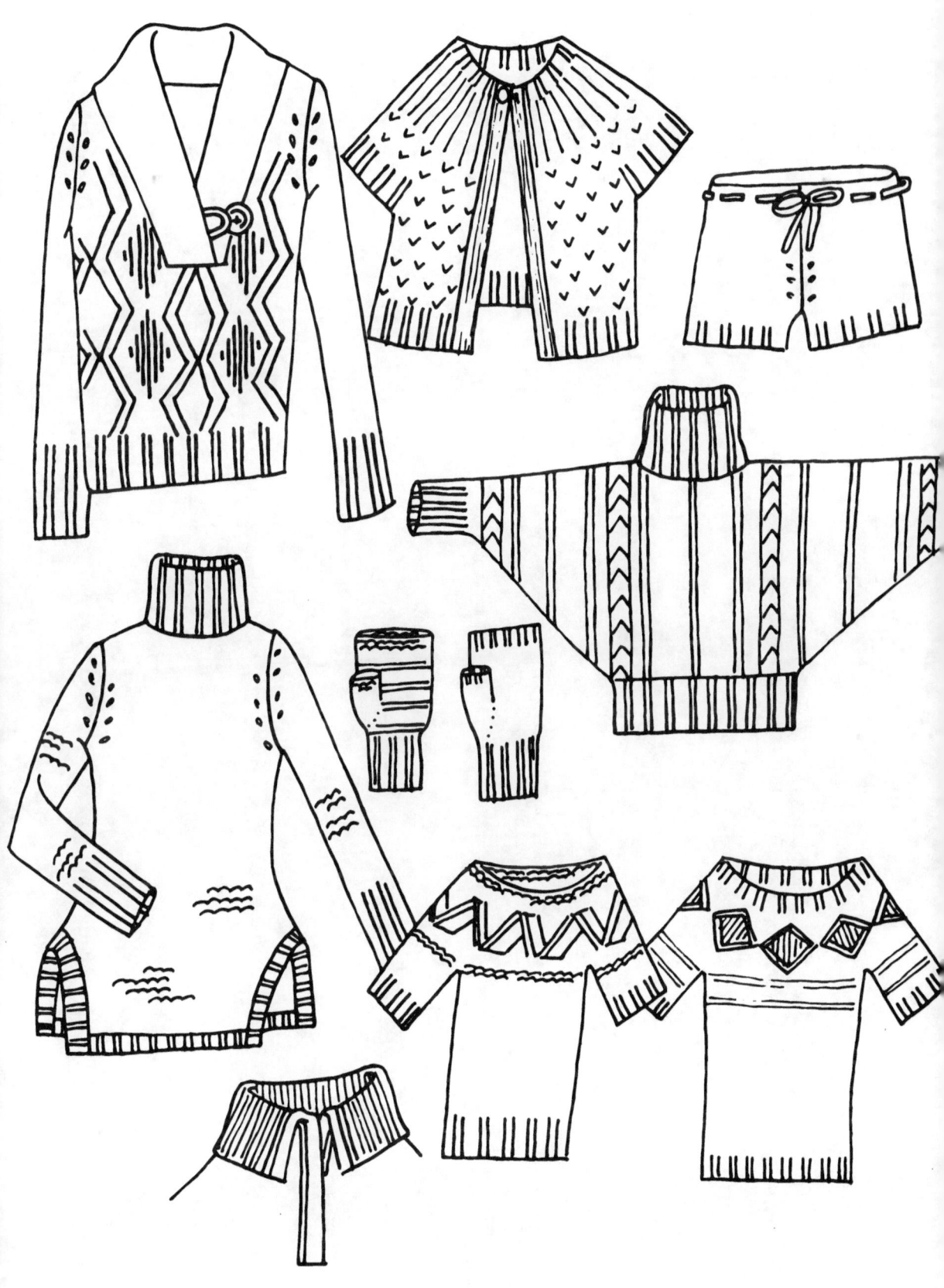

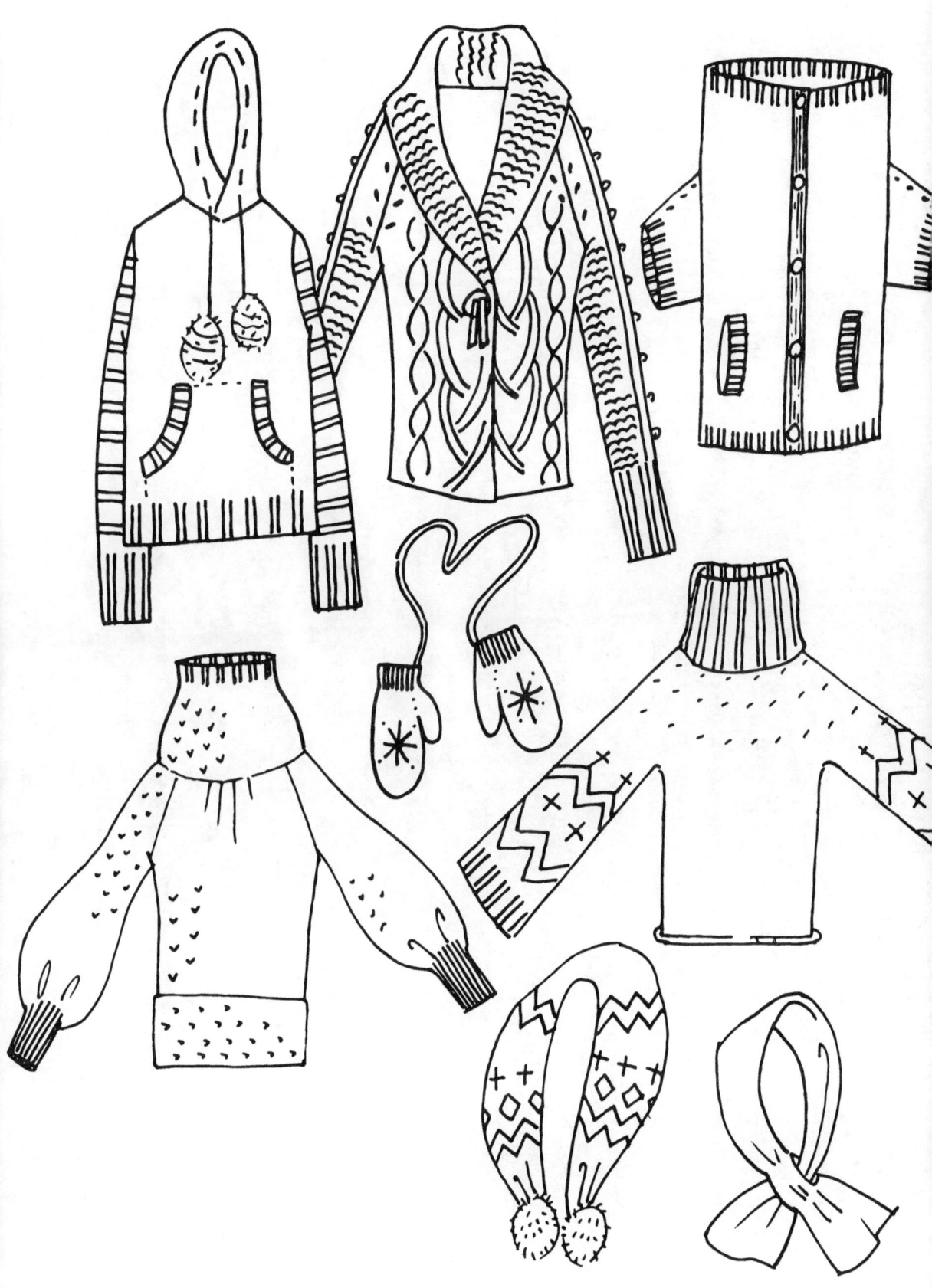

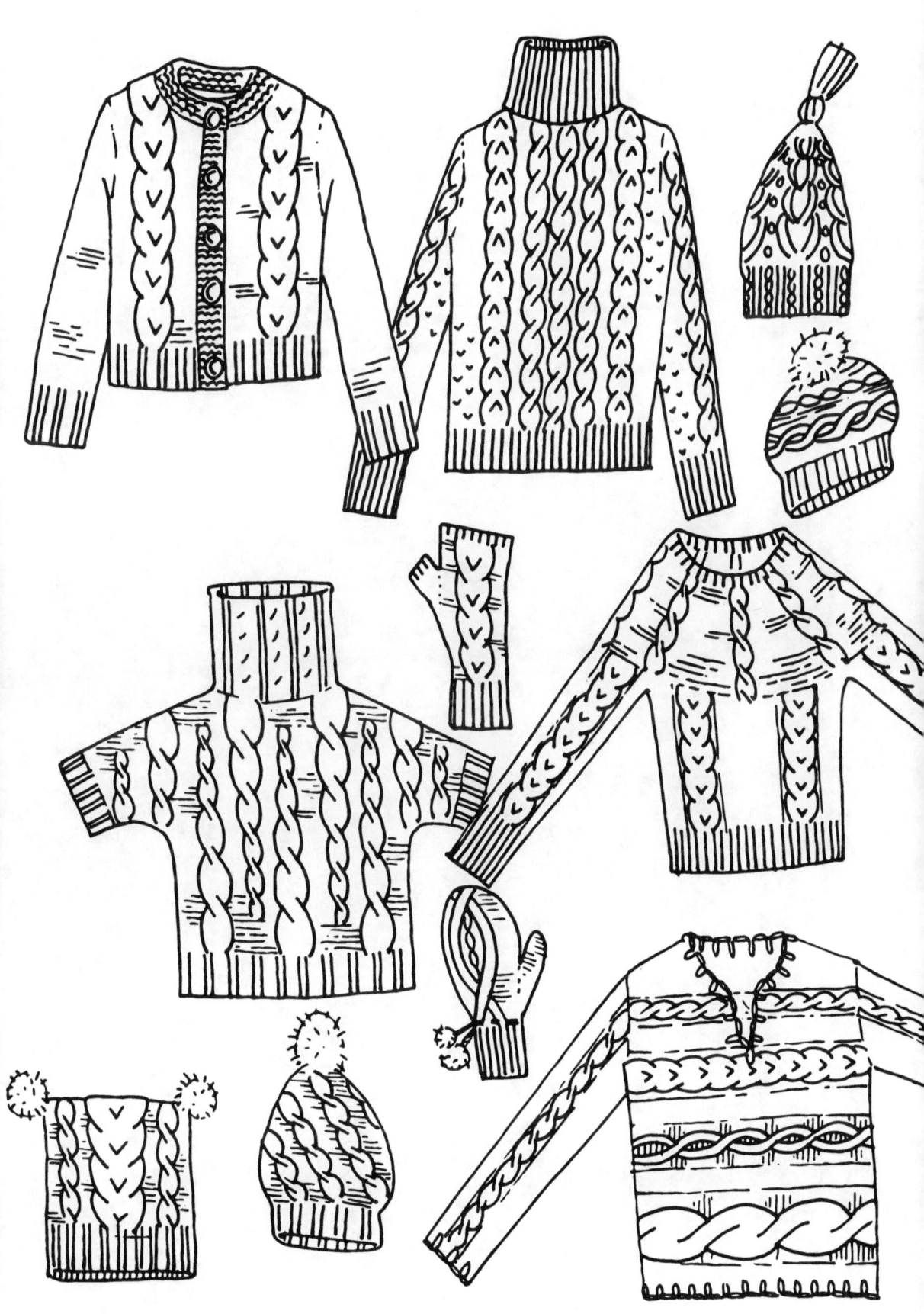

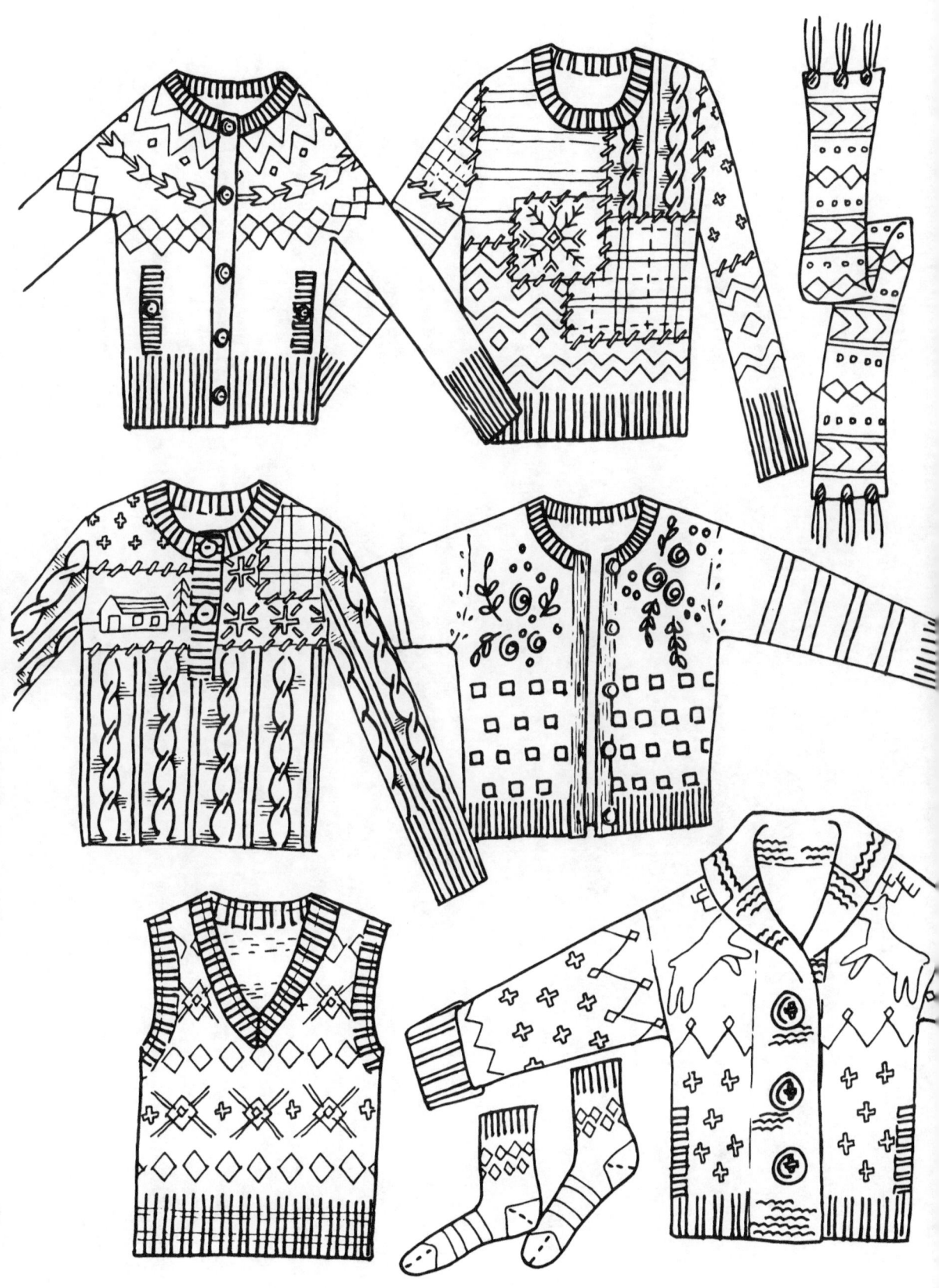

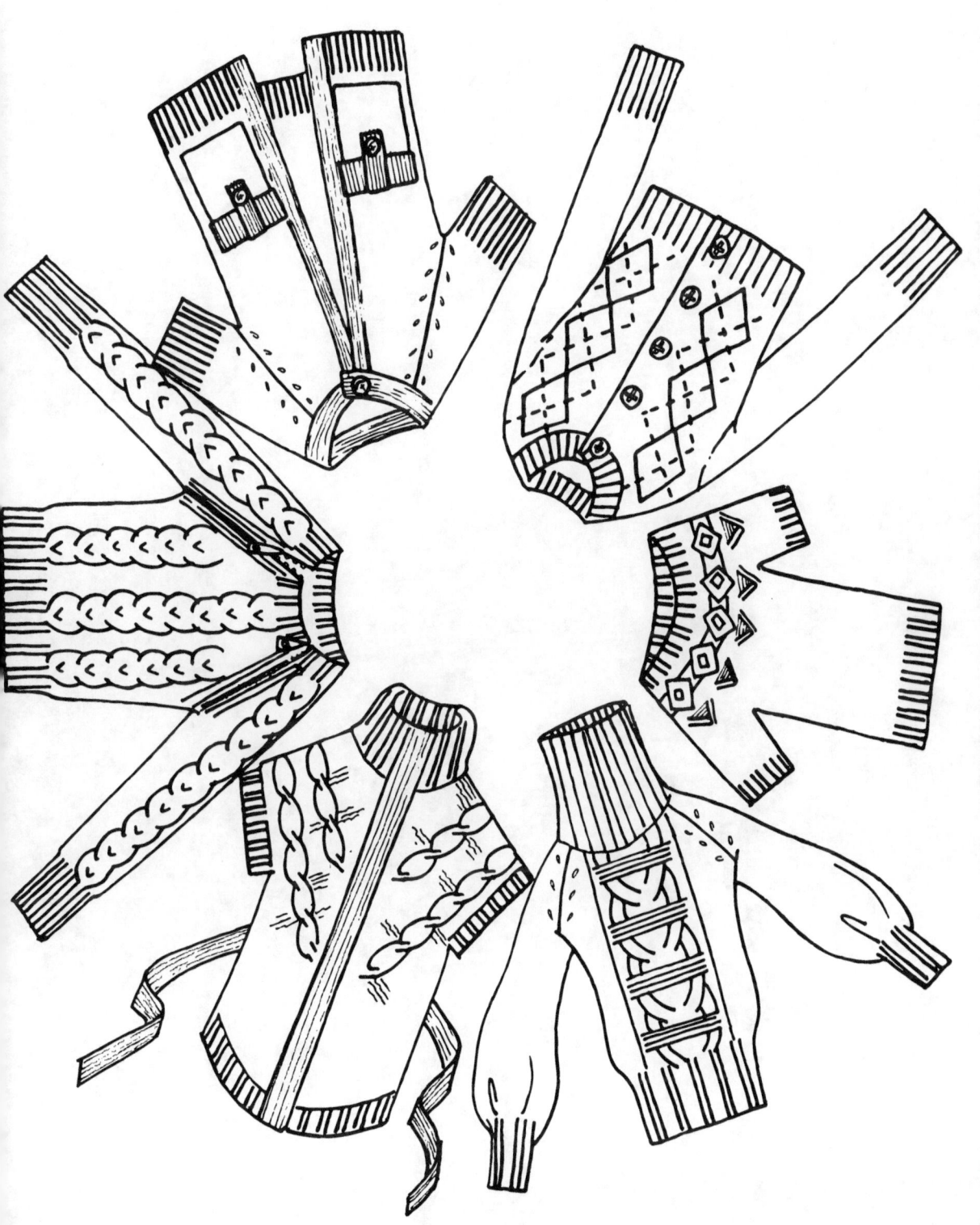

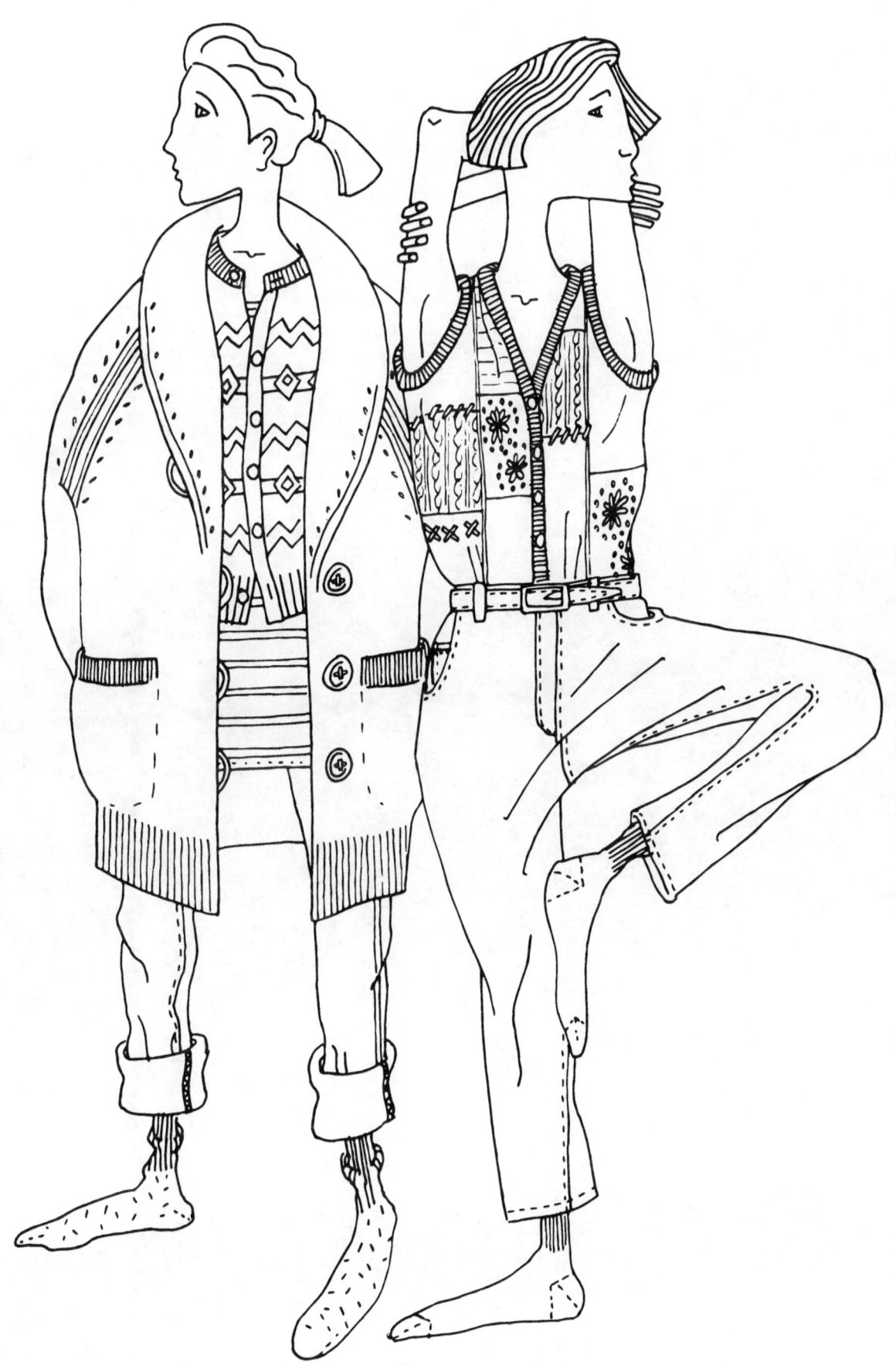

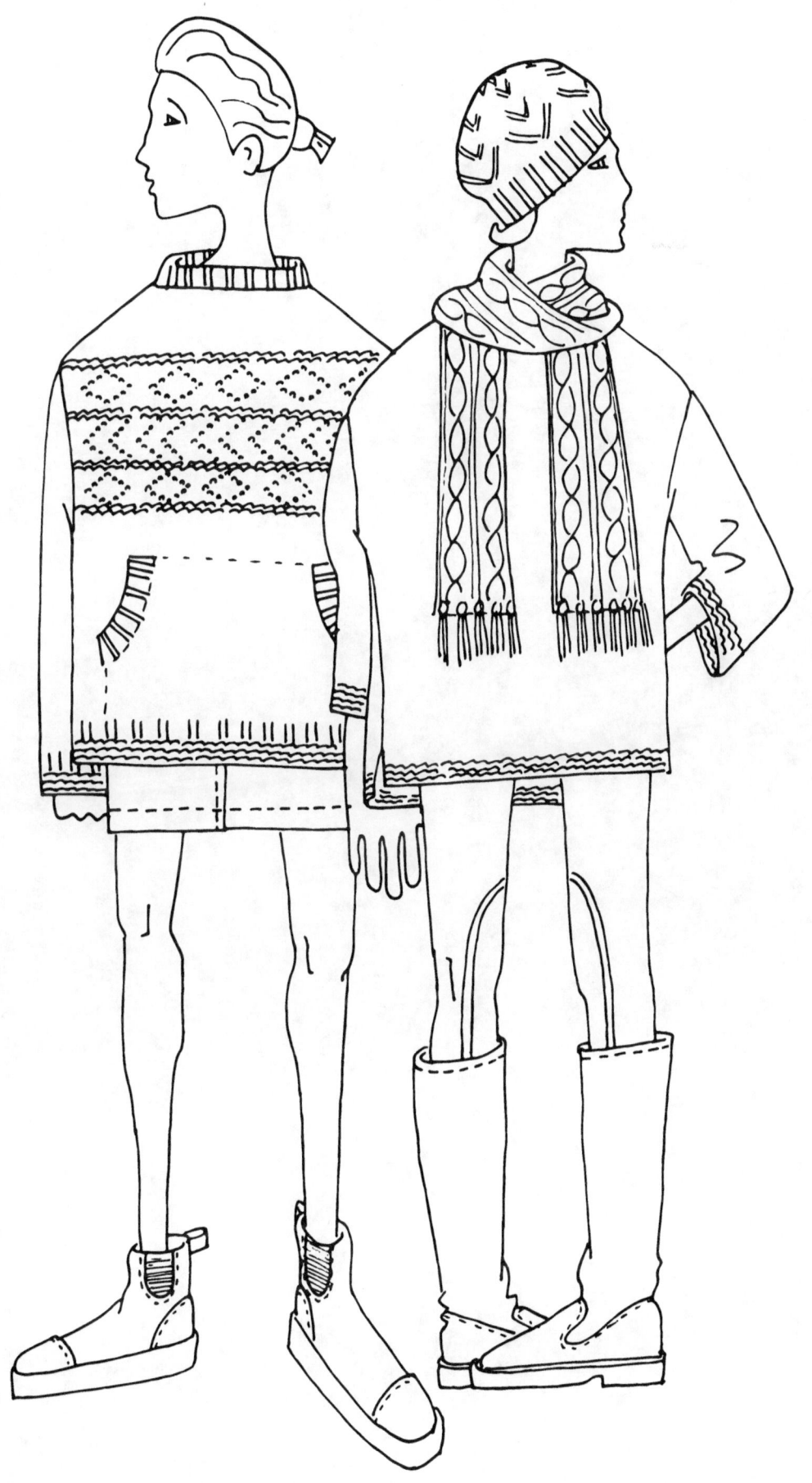

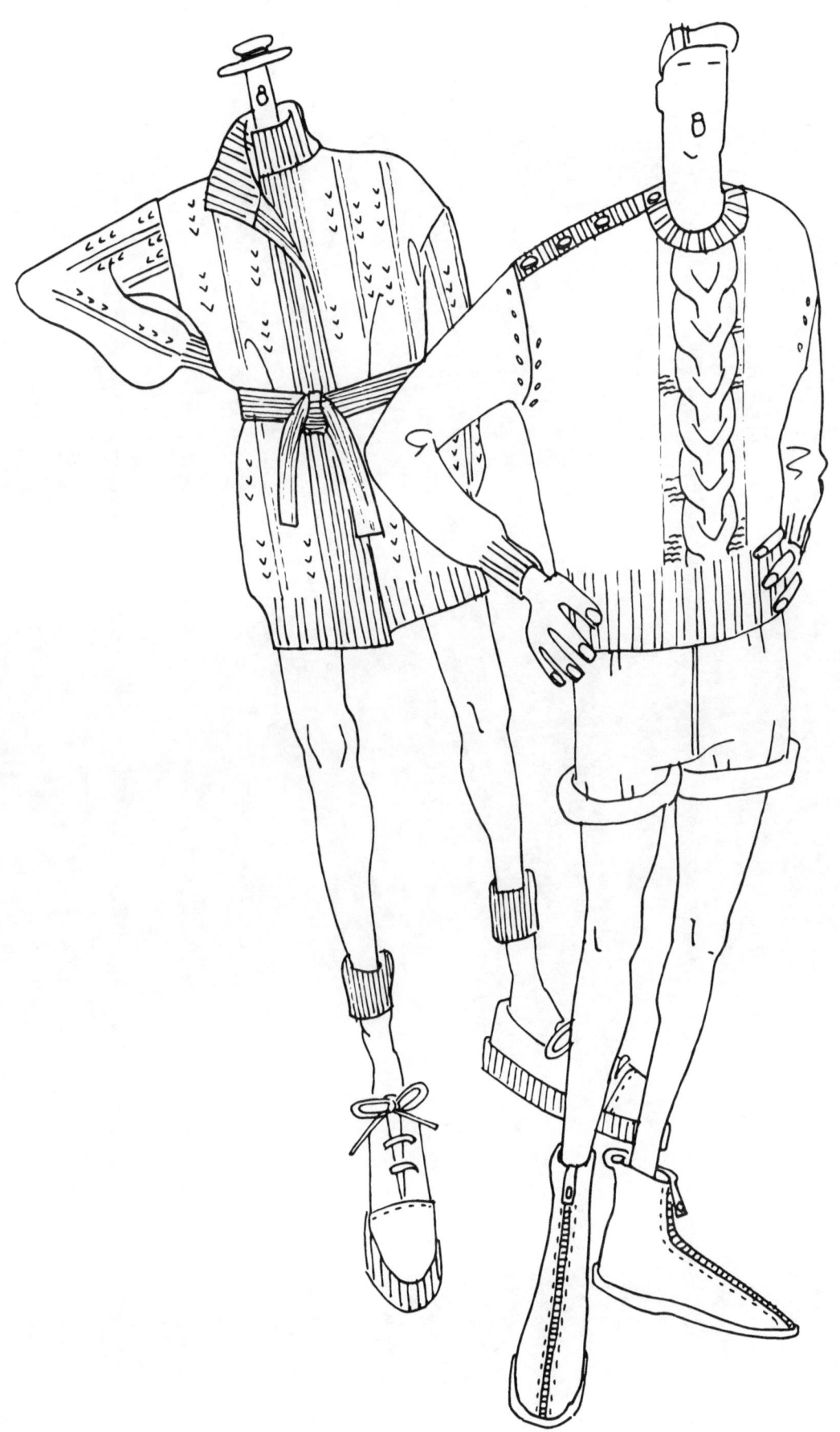

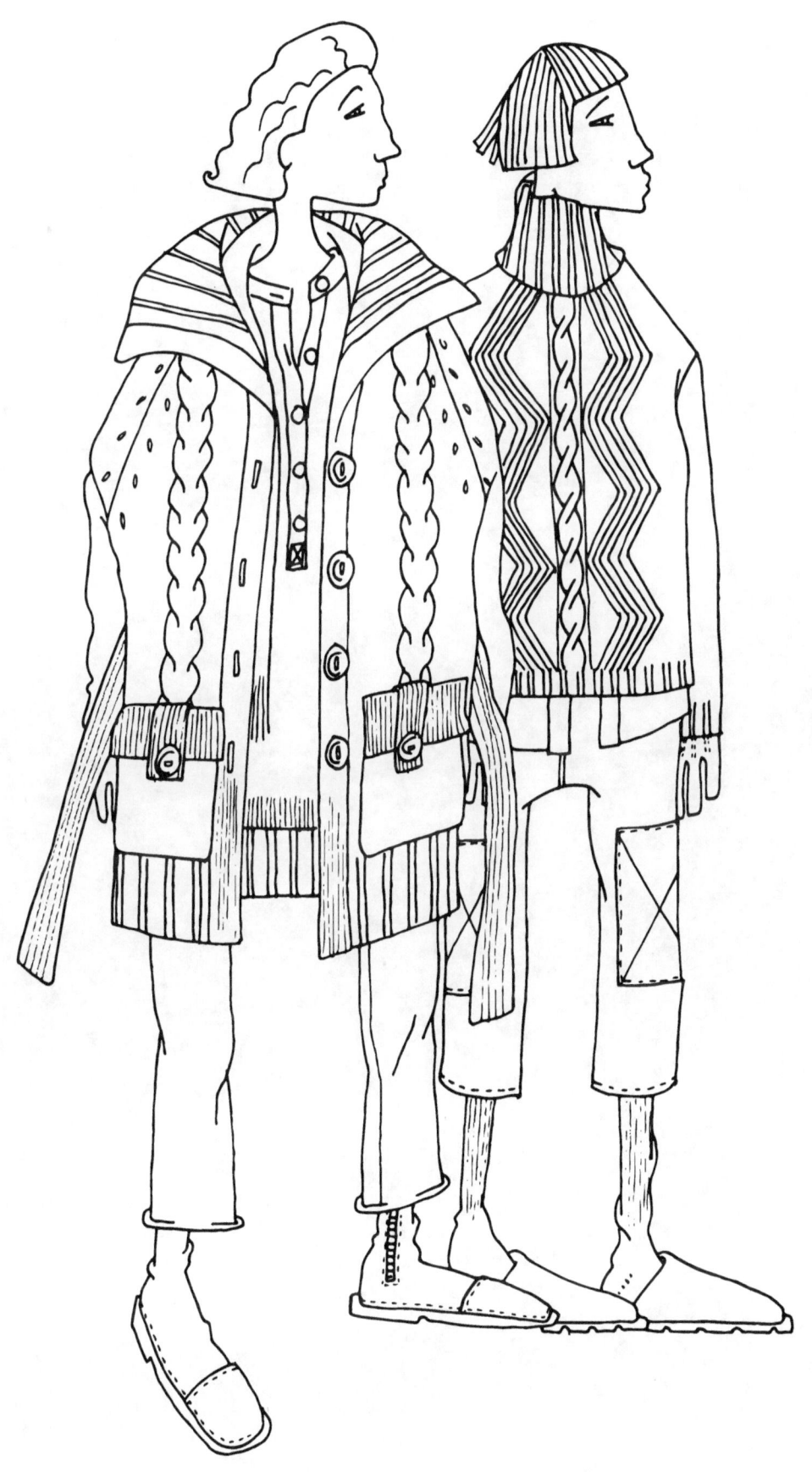

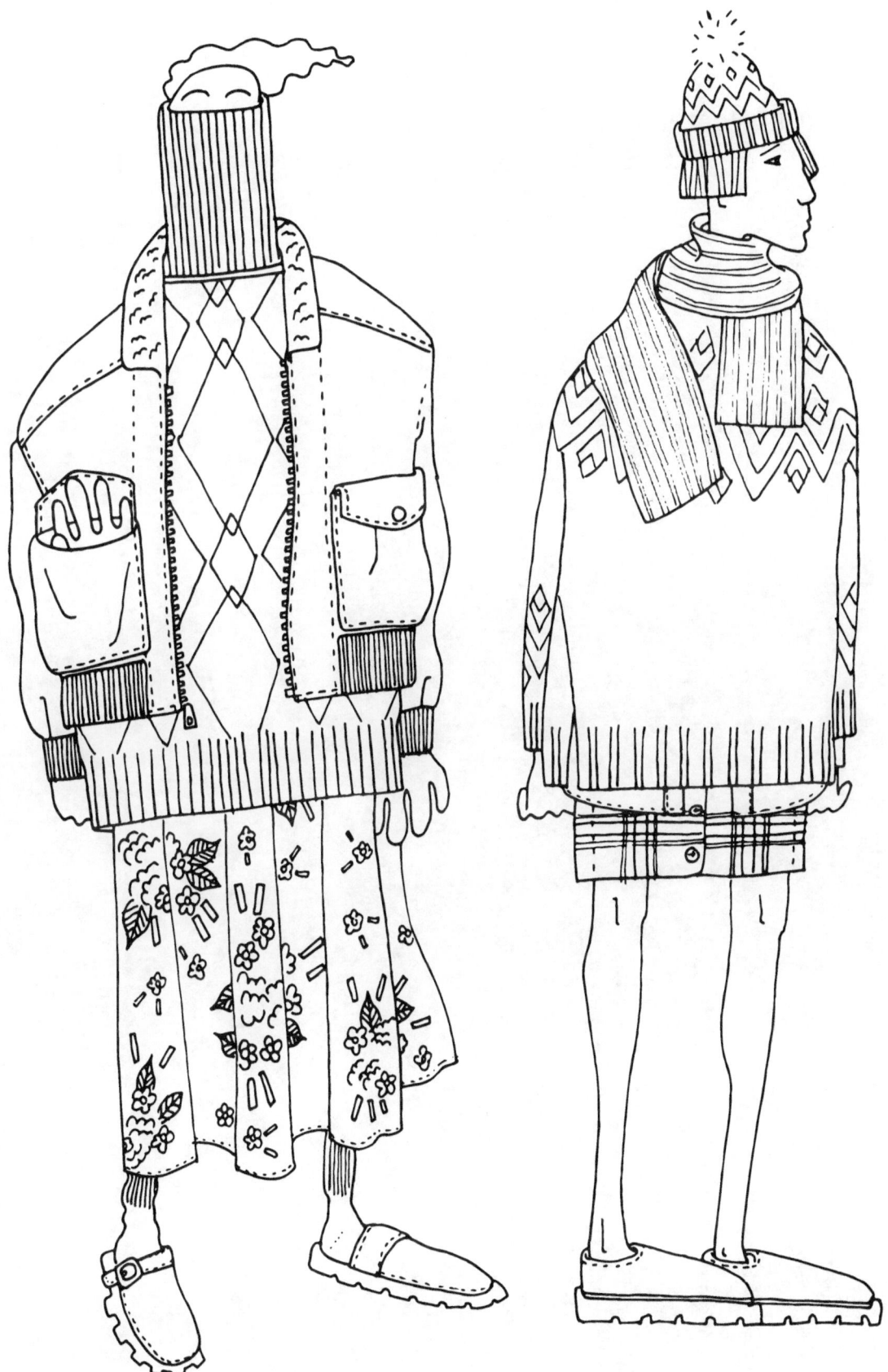

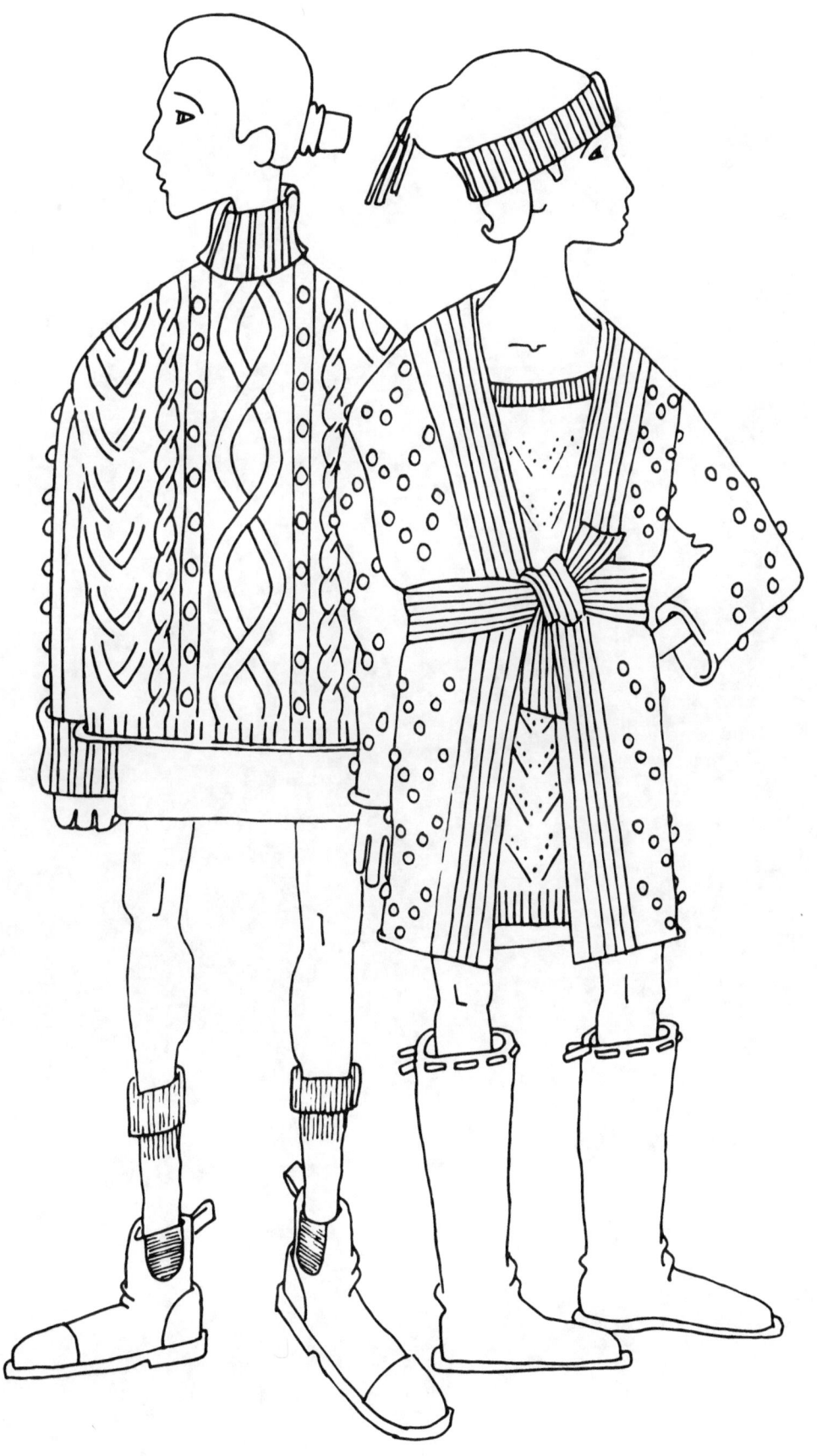

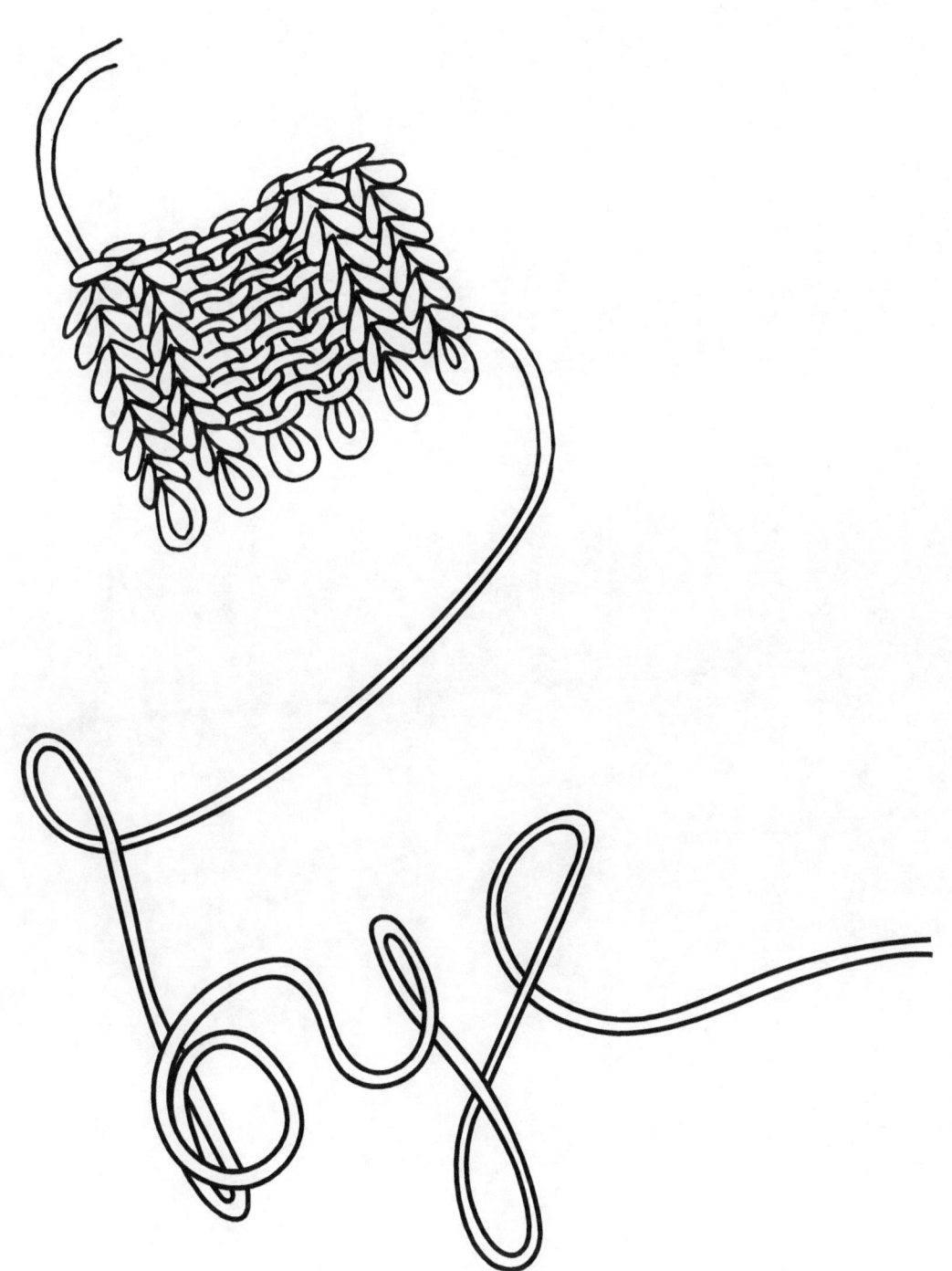

www.ingramcontent.com/pod-product-compliance
Lightning Source LLC
Chambersburg PA
CBHW080631190526
45169CB00009B/3352